Notices & Disclaimers

Bad Influence is a printed zine produced by Lisa Vollrath of Ten Two Studios. The articles and images presented here are for your entertainment only.

Photos on pages 4-5, © 2007 by Corinne Stubson. Photos on page 6, © 2007 by Carolyn Brady. Photos on pages 7-15, © 2007 by Lynn Dewart. Photo on page 17, © 2007 by Jen Worden. Photos on pages 18-20 are courtesy of Wikimedia Commons. Photos on page 21, © 2007 by Diane Ferguson and Scout Granier. All other contents copyright © 2007 by Lisa Vollrath and Ten Two Studios. All rights reserved worldwide. No part of this document may be reproduced or transmitted in any form, by any means (electronic, photocopying, recording, or otherwise) without the prior written permission of the publisher or copyright holders.

This publication is protected under the US Copyright Act of 1976 and all other applicable international, federal, state and local laws, and all rights are reserved.

Any trademarks, service marks, product names or named features are assumed to be the property of their respective owners, and are used only for reference. There is no implied endorsement if we use one of these terms.

Artists in This Issue

Diane Ferguson lives in the Houston area, and in addition to her mixed-media work, is an accomplished weaver and fabric artist. Her art can be seen in her blog at soonerorlater.blogspirit.com.

High atop a rural Nova Scotian drumlin, **Jen Worden**'s art is influenced by her physical surroundings. Mixed with paper and paint, rusty things and nature's detritus, it is this journey that continues to intrigue and enthrall, and, hopefully, grow as an artist.

Corinne Stubson is a mixed media and book artist, residing in Southwestern Oregon. She creates artistic statements using books, canvas, found objects, and more. Corinne's art can be viewed on her website at glitz-oh.com.

Carolyn Brady creates mixed media art and does freelance historical research in Muskego, Wisconsin. She is a member of the Ten Two Studios Design Team.

Scout Granier is a stay at home mom who creates a wide variety of stuff using every conceivable media in her spare time from her job. she is honestly surprised she gets anything done at all.

Lisa Vollrath is a prolific mixed-media artist. Her work covers a multitude of techniques, from altered books to collage, from artist trading cards and decos to textile art and costume design. She has written dozens of books and how-to articles for arts and crafts publishers. Her current work can always been seen on her ever-growing web site, LisaVollrath.com.

A Few Words From Lisa

When I was a little girl, I collected dolls. My grandmother started me off with dolls that she made: big, frilly things made from circles of organza joined with rosettes and knots of floss. In the twenties and thirties, these were called boudoir dolls. They weren't made for play. They were made to sit on a bed and look pretty.

I've kept my early fascination with dolls, though the ones I collect now bear little resemblance to grandma's boudoir dolls. Now, I'm attracted to dolls made of sticks and bones and metal pieces.

In thinking for a theme for this month's issue, I wasn't really focused on dolls. Flipping through the finished pages, I see that's exactly where my thoughts were. As soon as I chose Sticks and Bones as my jumping off point, the work of my friend Lynn Dewart came to mind. One of her little Bone Gatherer dolls has spent the last year on a hutch overlooking my kitchen, supervising the goings on. Lynn has been a steady source of inspiration for me over the years, so it makes me happy to include so much of her work with that of the other artists who participated in this month's issue.

Brace yourself for some interesting stuff...

Art By
Corinne Stubson

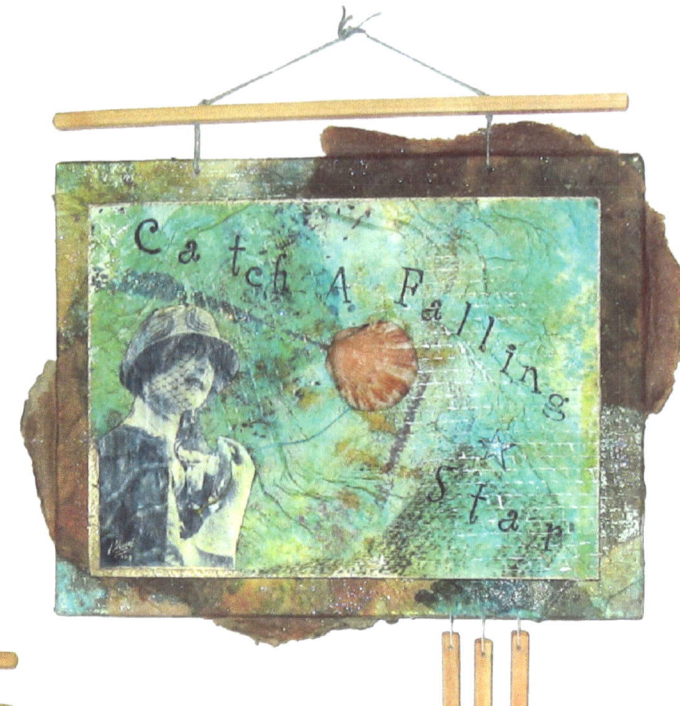

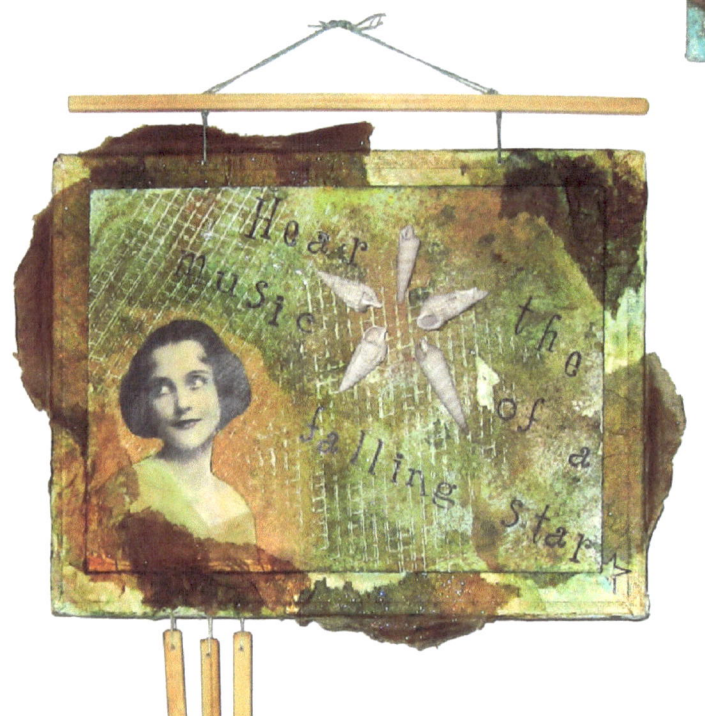

Sounds of the Universe
Windchime Collage

Above: Side One - Catch a Falling Star
Right: Side Two - Hear the Music of a Falling Star

art canvas, watercolor paper, paper towels, dye inks, acrylic adhesive, Ten Two Studios collage images, bamboo chopsticks, seashells, silk thread, linen thread

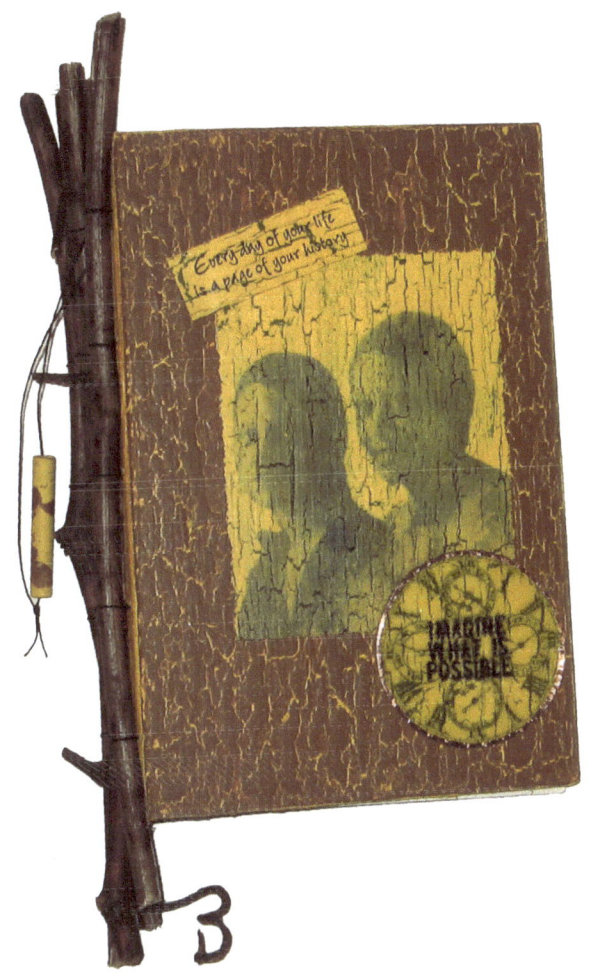

Imagine
Stick-Bound Journal

grapevine sticks, images from Thelzeda's Photo Album CD by Ten Two Studios, book board, acrylic paints, crackle medium, coverstock-weight paper, lokta paper, waxed linen thread, UTEE, copper foil tape, rubber stamps

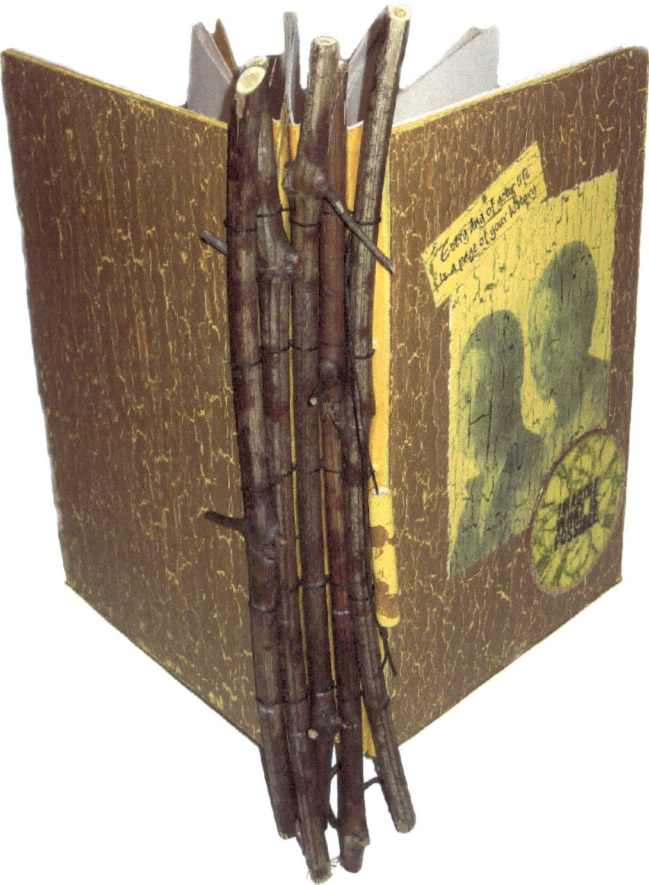

Art By
Carolyn Brady

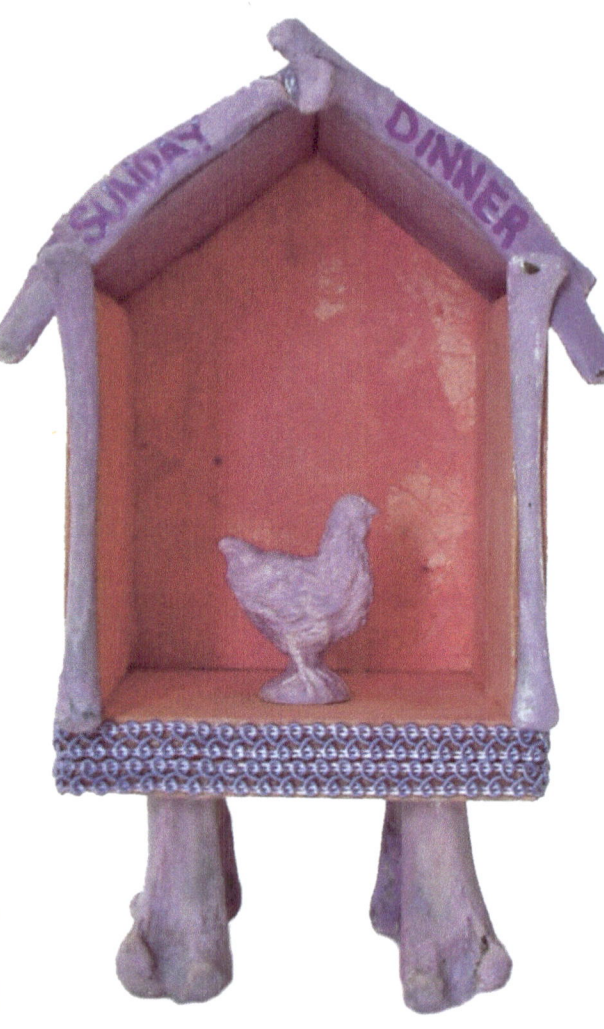

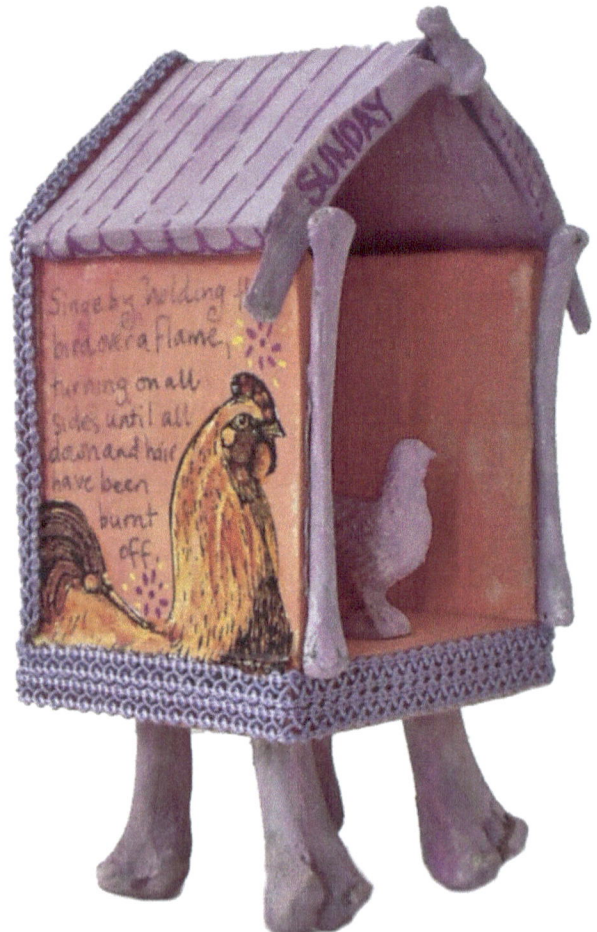

Sunday Dinner
Assemblage

chicken bones, foam-core covered with mulberry paper, plastic chicken, chicken images, acrylic paints, woven trim, Dover images

"I wanted to make a colorful little box that would look bright and cheerful from a distance but become more sinister on close inspection, so the legs of this henhouse are made from drumsticks sawed in half, and more bones frame the toy chicken inside. The handwritten text quotes a 1940s cookbook in which the directions for preparing poultry start with "cut off the head"."

From the Land of ze Voodouqween:
The Art of Lynn Dewart

I first met Lynn Dewart while swapping ATCs at Nervousness.org, back in 2002. Over the years, I've had the pleasure of viewing the many facets of her work: her adventurous costume designs, her edgy mixed-media work, and her brilliant fabric sculpture art dolls.

Two years ago, I saw a radical change in Lynn's work. As her friend, I knew the reasons for the change. As an artist, I marveled at the transformation. When I asked Lynn to talk about how her life and work fit together, she bravely agreed:

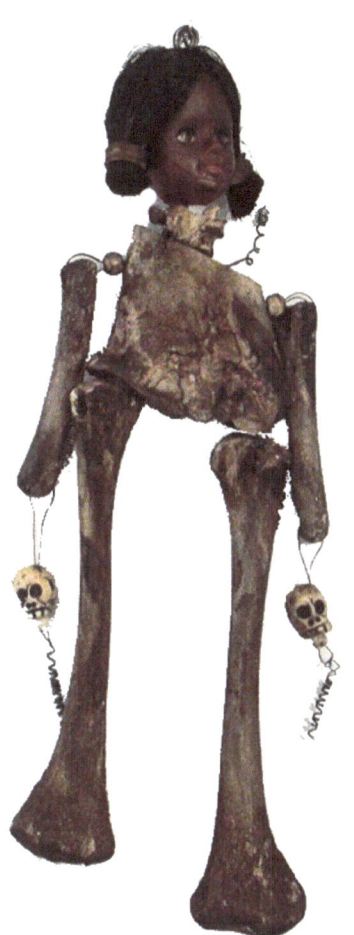

This tiny Bone Gatherer, small enough to fit on the palm of your hand, is one of four Lynn made. I was thrilled when she gifted me with one of them on my last birthday.

Tell us a little about where you're from, Lynn.

I currently reside in San Diego, California. I was born up the coast about 30 miles. I've lived in Paris, France; Maracay, Venezuela; Carson City, Nevada and back to Southern California. All these places, peoples and cultures have informed my art.

What do you do for a living?

I make art, make costumes, and teach workshops.

So your art is your living. Did you train to become an artist?

Beginning in elementary school through the 10th grade, I had formal art lessons from the increasingly acclaimed Belle Baranceanu, now recognized as San Diego's premier painter. She laid a foundation I still work from today, in that she was an independent, free-thinking woman who walked her own path, passionate about art and art education. She's the reason I volunteer to teach art in public schools today, since art was deleted from the curriculum by the current governor.

How would you describe the type of art you do?

Mixed media fiber artist? Personally, as one whose nature is to push boundaries, and with a passion for creating an inclusionary world, I deplore labels. Someone once defined me as an auto-didact. I do consider myself truly self-taught in that I don't take classes to learn techniques and applications. I figure things out for myself. I do not want to emulate other's styles or copy someone's technique, though there a few who have definitely influenced my work. Some refer to me as an outsider or a visionary and I accept that in part, though it's just another label.

I make free form soft sculptures, art dolls, voodou dolls, marionettes and cloth art books. I make altered books, and other sorts of paper and fiber related book forms. I like to make artist trading cards. I paint from time to time. I sculpt some, too.

I know you do a lot of costume design work. Do you consider that part of your art, something to put food on the table, or is it somewhere between?

I do consider it part of my art as it draws from my sense of esthetic design and it has informed my other art as well. It does put food on the table, too. I seem to most often swing between the two. I will have a frenzied period of costume work which pays the bills so I can take time to make art. I do not mix the two as the first is definitely deadline oriented and the hours can be long and it fills my world, my mind, taxing my imagination and problem-solving skills. Then I take a little break and ideas for art, dolls, books start to come to the forefront. I like the rhythm. It suits my nature very well, as I like change and the variety of tasks and demands is stimulating.

Which came first: clothes, art dolls or mixed-media work? How do those things fit together?

Clothes came first. My mother made all our clothes when we were kids. I watched her at her old Singer sewing machine, and it was not long before she was teaching me to make small things for my Barbie doll. My grandmother taught me to knit a dress for the doll. I was hooked on creating my own fashions, first out of necessity, then for creative freedom.

By junior high school, I could do something about the things my mother was making for me that made me cringe (due to the difference in style and times). It was time to go get a job so I could buy my own fabric and sew my own clothes. The rest is history. I've been making my own clothes pretty much ever since.

I learned to spin and weave and dye when I lived in Paris, and that cemented me in the fiber arts. I did not make art for many years, and came back to sewing when I left the corporate world and sat down to find out what in the world I wanted to do with my life that would give me some peace. A series of synchronous events let me to doll-making. As I'd worked in other media before, it felt natural to begin to combine them with my fiber work in doll making. I credit the original nervousness.org and mail art with bringing out the mixed media artist in me.

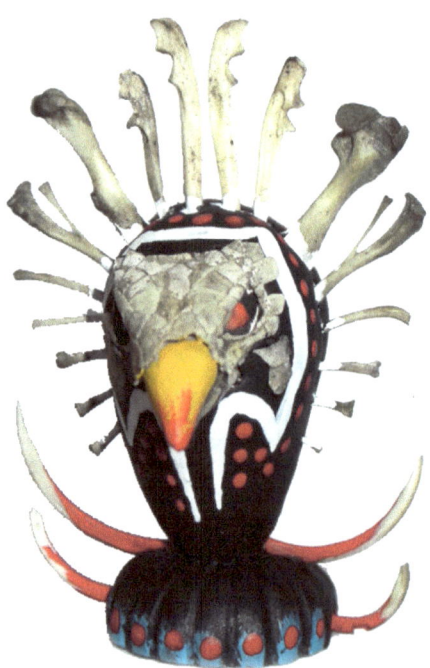
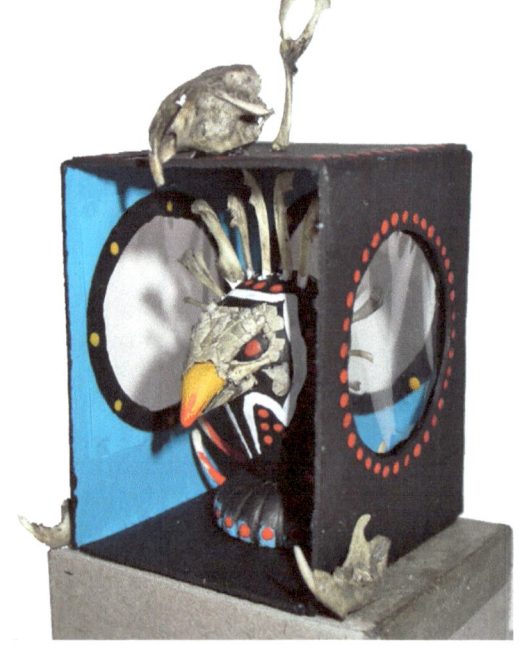

The first bone sculpture Lyn created was this piece done for a swap at Nervousness. Barely 3 inches tall, the tiny piece was made from the bones harvested from an owl pellet.

How did you develop your art doll style?

It comes purely from my imagination and a desire to create a sewn sculptural piece. I am fortunate, too, that many dolls have come to me in dreams, and I simply answer the call, knowing better, now, than to try to improve on what my subconscious provides me.

After making my very first doll, I met a couple of women from the bay area who had a series of dolls they'd made for an exhibit about gender. I'd never seen such wildness, such liberated expression of form. I went on to make my first wild creatures, then found the newly published book "Women Who Run With The Wolves". I found words that expressed what I'd believed for years.

Taking my appreciation and interest in mythology, folklore and anthropology, I focused on the 'zen' of creativity, that process is more important than the outcome. I held to that practice for a very long time and for some works, it still holds true. For those works, I did not plan or contemplate an outcome, but allowed my subconscious or intuition to guide the action. I purposely did not pay attention to balance or format. The pieces I began to create helped to prove to me how limiting some thought processes can be, especially to creative expression. I was intent on freeing myself from what others think. I was intent on healing myself on many levels, to continue to explore the range and depth of what my very first doll experience introduced me to. I took my appreciation and interest in mythology, folklore and anthropology and found a much larger, broader and wider illustration of the complex human condition, specifically feminine.

I did not set out to create dolls. In fact, when I began making my pieces, art dolls were still uncommon, and anything doll related was not accepted as art, I set out to create fabric or soft sculptures that would embody what I needed to express. It was a number of years before I ever associated the word doll with them, other than my voodou dolls. That is because, there again was a realm outside the comfort zone of many, where I was perfectly at home.

I also like to allow the fabric to inform the shape of a piece. For instance, I do not try to control the effect some bias give might create.

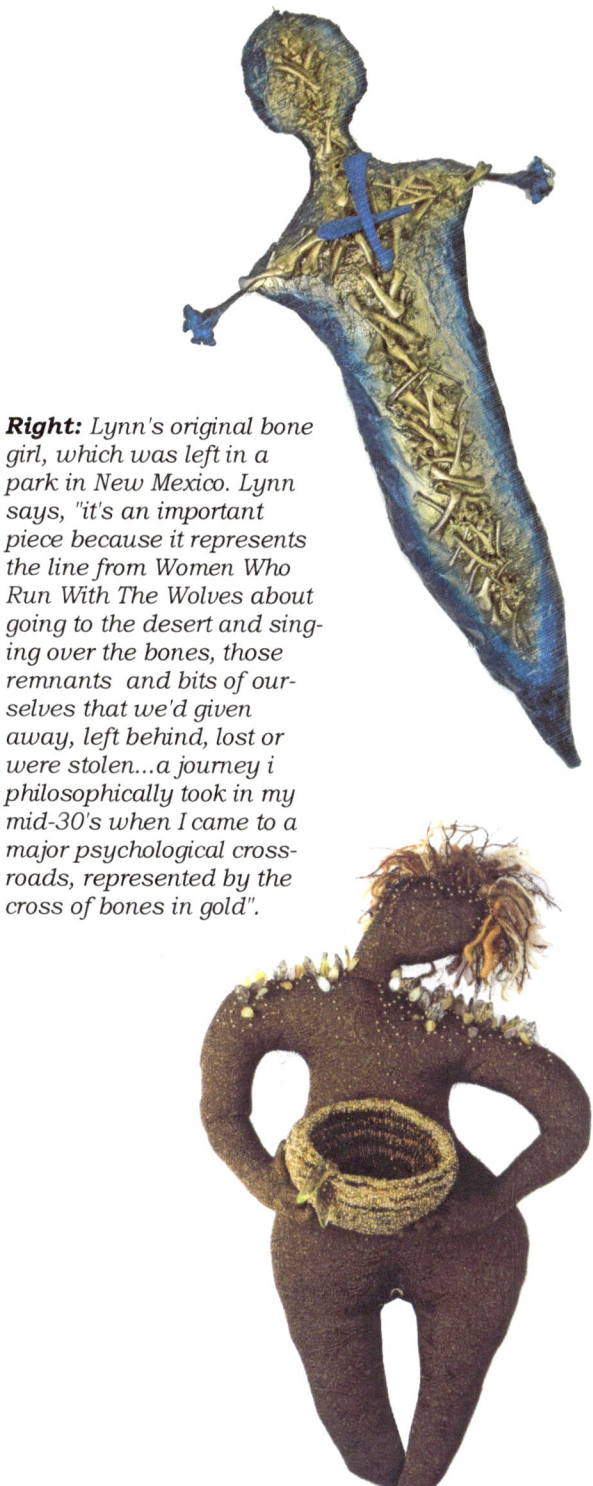

Right: Lynn's original bone girl, which was left in a park in New Mexico. Lynn says, "it's an important piece because it represents the line from Women Who Run With The Wolves about going to the desert and singing over the bones, those remnants and bits of ourselves that we'd given away, left behind, lost or were stolen...a journey i philosophically took in my mid-30's when I came to a major psychological crossroads, represented by the cross of bones in gold".

Above: One of Lynn's cloth doll sculptures, Demeter, represents the Earth element. Demeter was part of a series of four elemental sculptures in an all-woman show at Sumner and Dene.

Most of your doll sculptures don't have faces. Is there a reason for that?

I am not really interested in imitating life. Our outsides are what set us apart. More often than not, it's the first thing many people judge about us as humans. I want to work with, express and connect with another's insides. I want my subconscious to connect with your subconscious. It also reflects my frustration with the society we live in, that pays far too much attention to one's outsides, which more and more are manipulated and altered therefore false and misleading, instead of who and what we are inside. "Inner Piece" is specifically about "we are so much more than what we look like."

I've used masks when I wanted to create a face, allowing me to emphasize the existence of personas, and the fact that such and such a nature is possible in all of us, reinforcing my desire for an inclusive society rather than an exclusionary one.

Can you talk about how an individual doll develops? Do you do sketches? Does the inspiration come from the fabrics, or the fabrics from the design?

All of the above. Sometimes, they come to me in dreams: the shape, the color, the outline. Sometimes, I do sketches, sometimes I sew freeform on the machine. Sometimes I am inspired by a tale or myth or icon, and sometimes just by a word or a piece of fabric. In fact, when I am setting out to create a body of work for an exhibit, I sort through my drawers and bins and bags of fabrics. The tactile as well as visual stimulation shakes things loose.

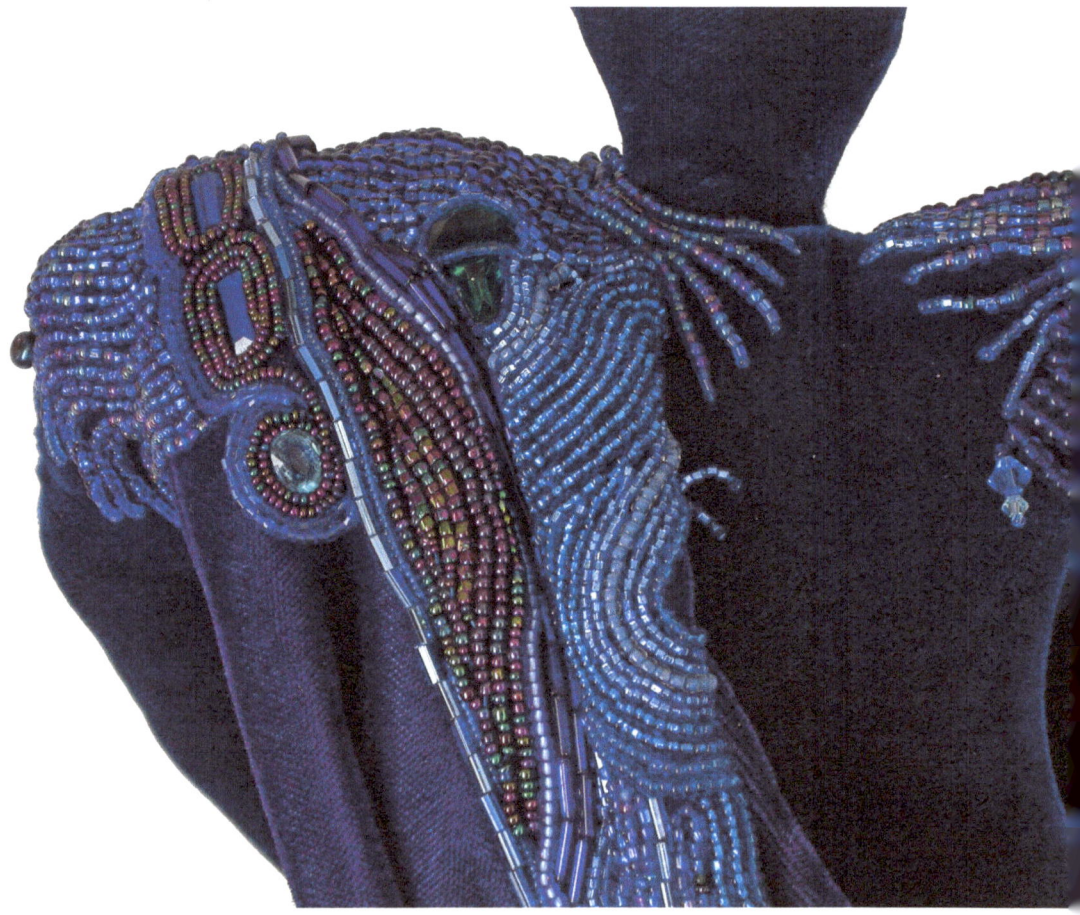

This detail from Lynn's 19 inch fabric sculpture doll Key of Blue shows the amazing complexity of her beadwork, a feature that often appears in her cloth pieces.

I know you've worked with galleries quite a bit. Can you talk about that process?

I did not set out to show or sell my work, I set out to work on myself, using some ancient techniques of dolls as tools for transformation. It was some time before I even shared my work with friends. In fact, I threw myself a 40th birthday party and decided to hang and display some pieces for my close friends to see, without any form of announcement. I simply wanted to see their reactions, which were enormously gratifying, Then, I was invited to exhibit, but was not interested in selling any of my work and again, received enthusiastic applause and reviews.

On the instructions of a friend and mentor in the art world, I began to research galleries and manners of approaching them. I introduced myself to an artist whose work I'd admired for some years, and who'd had gallery representation for almost 20. I asked if I could take her to lunch and pick her brain about the ins and outs. I received some great recommendations and tips. As was the preferred formal format then, I sent out brief introductory letters with slides to a few galleries, and was invited immediately by one of them. Since then, the introductory process has changed, as some galleries and stores will accept color copies of prints and even emails and website images. This is not always the case, though.

How difficult is it to put your work out there for inspection by gallery owners?

It is still not a comfortable experience. I am a tender-hearted and sensitive person, and innately shy and introverted. I am very lucky to have a few relationships with gallery owners who treat their artists with great sensitivity and respect. This is a great reward, and so good for one's work. I still watch carefully their responses to new works, especially major changes. I hold dearly to those who encourage through their appreciation.

I used to practice contacting three new galleries a year, and have let that fall by the wayside in the last couple of years. I'm in some transition again and don't know which direction I might be headed next.

(Editor's note: names and addresses of the galleries that represent Lynn's work can be found on her web site, LynnDewart.com, in the Gallery Affiliates section.)

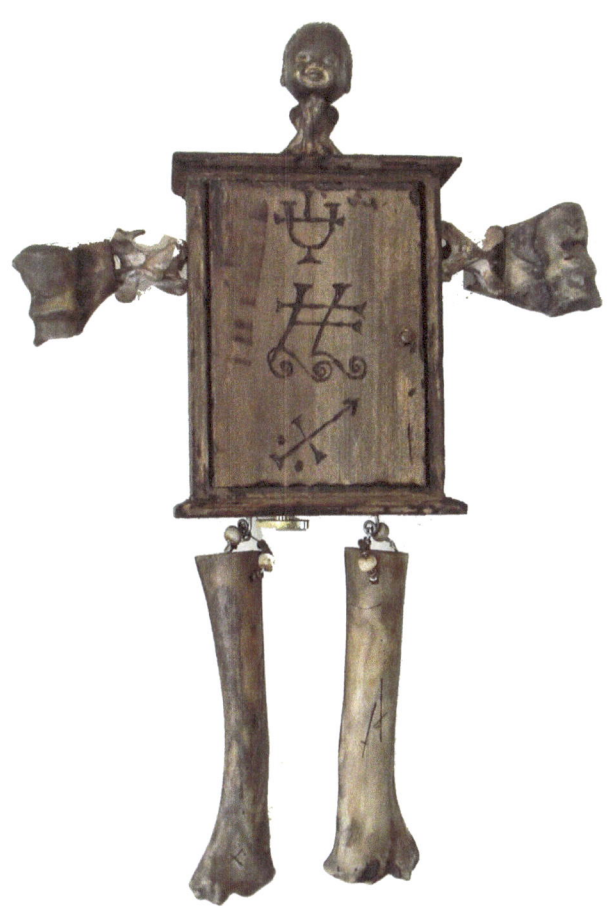

No Goodbyes is the first box Lynn made about her niece Allison, and it is filled with symbols of her life. The little jogging man figure atop the movement turns like a ballerina would, and represents Allison's first true love, Zachary, who runs after her in vain

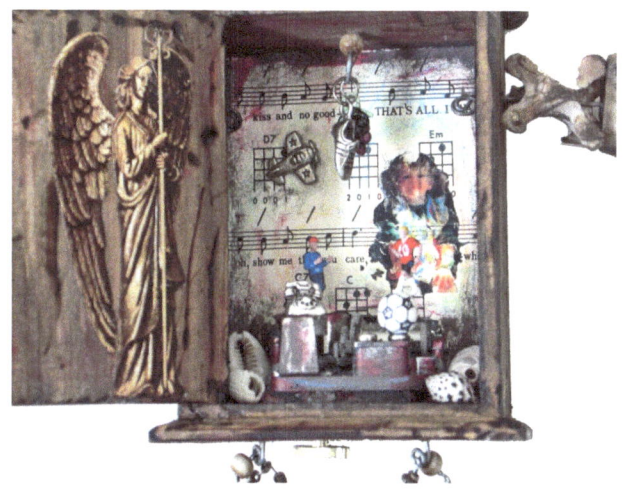

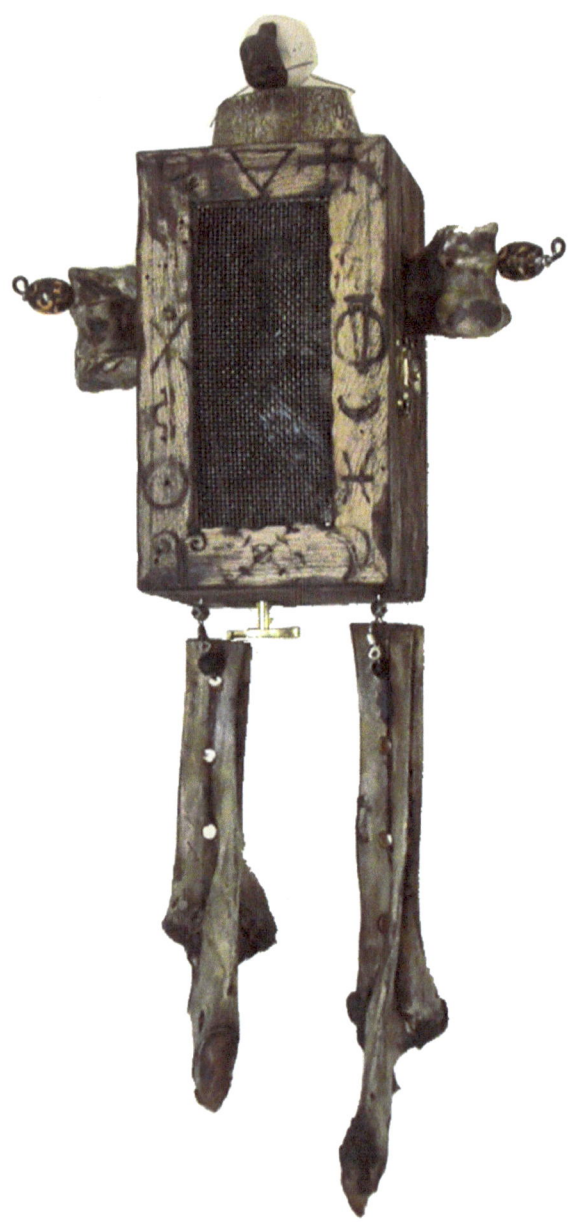

Since the theme of this issue is Sticks and Bones, I want to focus now on the Bone Girl Music Boxes. Where did the idea for this series come from?

The Bone Girl Music Boxes first began to form in my imagination after my dear friend and work partner lost her 14 year old daughter in a tragic auto accident in 2004. I'd worked with bones before. When i thought about young Sophia and how to express the enormity of what I felt, bones came back to mind. And dolls, somehow, and shrine boxes. I made some art dolls honoring the loss of this 'Tiny Dancer', as some of us knew her, mostly focused on her mother and what I witnessed happening to her. I imagined the first Bone Girl Music Box, and created two that were exteriors only. Then, 15 months later, my 18 year old niece was killed in another tragic auto accident. I was brought to my knees once again. The first pieces I created after her death were the tiny Bone Gatherers and "Rising Star", a memoriam shrine depicting the accident. It was a necessary step in my own acceptance of a once again altered reality. Then I set to work on the Bone Girl Music Boxes.

Since then, I've continued to explore alchemical symbolism, which I've used in my art for years, and the psychological interpretations of Jung along with the processes that Newton explored in relation to these recent encounters with death and dying. The Alchemical Series of the Bone Girl Music Boxes has some 6 pieces in existence now. Plus, I've created three other

This page: *Departure represents the beginning of Lynn's Alchemy Series. She says, "I contemplated what is it that happens to us when we die, not necessarily from a religious point of view, but more exploring my own beliefs, thoughts and feelings."*

Opposite page: *Dissolution from Lynn's Alchemy Series, dealing with the death of her niece Allison. Each of the boxes created about Allison contains something that she wore while she was alive.*

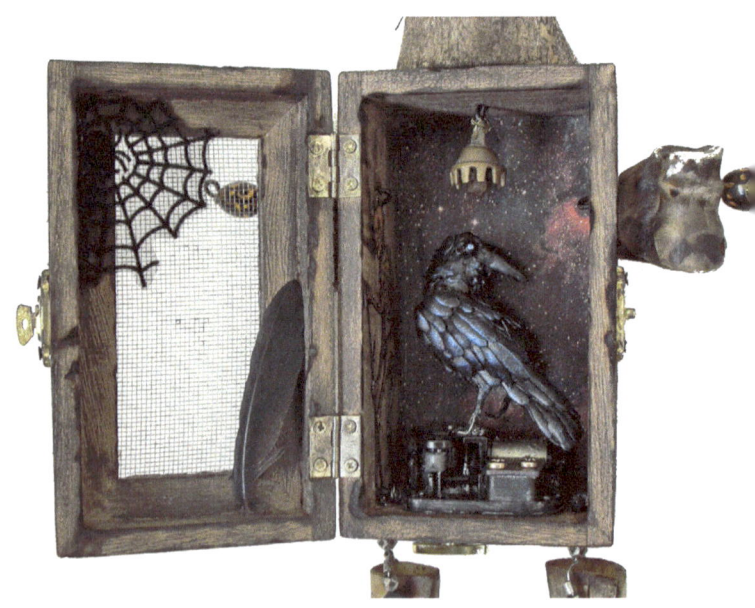

boxes about Sophia. I have a commission due in a couple of weeks for another music box about another 19 year old who was killed in an auto accident, just 3 weeks before my niece. I began working with the parents around her first *Yahzreit,* the Jewish tradition honoring the anniversary of a death, and will be delivering it in time for her birthday, March 18. As sad an occurrence as this is, I am honored to create works of art in this fashion and for this purpose, it truly is a calling.

I've gone on to create a new one-of-a-kind series of Bone Dolls, "The 3 Graces", as I contemplate what is left behind when we depart this plane. What mark do we leave on this world and those in it? What of our essence remains? What of importance is left? Do we leave behind our innocence and joy or bitterness, fear and misery?

In creating these memorial pieces, what lead you to do music boxes? Why the audio element?

I have nothing from my childhood other than a few children's books. One thing I often wished for was a small white jewelry box, that when opened revealed a pink satiny interior with a mirror inside the lid, and atop the drawers was a tiny ballerina in a real tulle tutu who pirouetted to a tune.

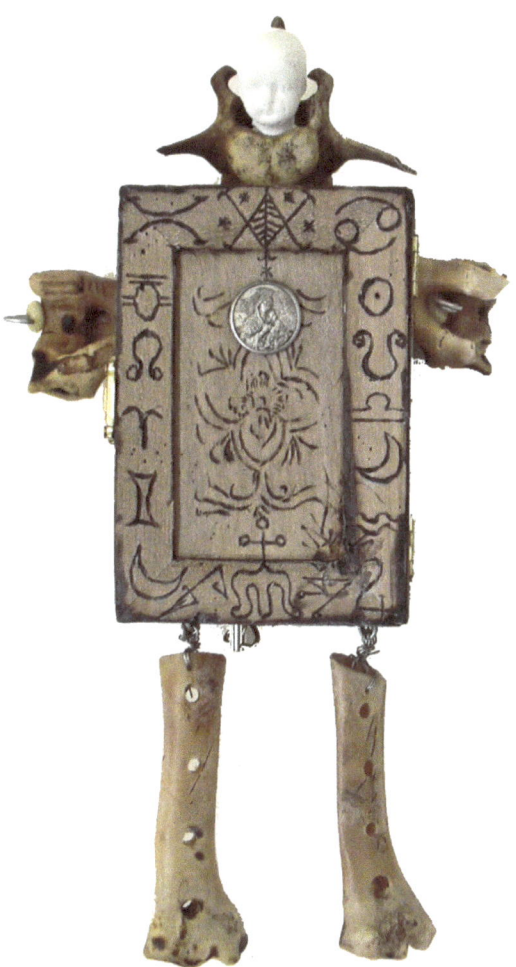

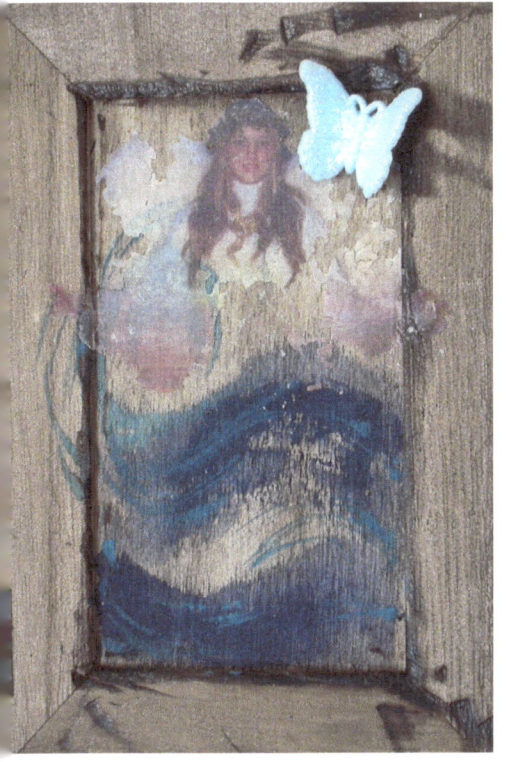

I have one music box bought in Switzerland when I was in the 10th grade. It amazes me how distinct the memories are of that month in the Alps when that tinkly tune plays. There's a romantic notion attached to music boxes. They speak to me of dreams and innocence, and even melancholy moments. I wanted to incorporate that sense memory experience into my Bone Girl Music Boxes.

How do you develop the idea for a box?

My process usually begins by sorting through the clutter and chaos that my studio becomes in much too short a time. Sifting and sorting and cleaning, I find objects forgotten that remind me of others, or which begin to form relationships that represent something of the person or notion. I may find a song title while sifting through papers for a background that sets the period. For "Jewel In The Sky", I knew I wanted a circus theme and scenario because that's the family and life that Sophia loved.

Thank you so much for taking the time to talk, Lynn. Any final thoughts about your creative journey you'd like to leave with readers?

I'm a storyteller and so are my artworks, my dolls. They began as exorcisms and turned into meditations on the human experience, the mundane and the divine, primarily, though not exclusively, the feminine. They each spin a tale or reveal a thread of some personal or global myth, some personal or collective experience, all towards healing ourselves and each other. Healing, in the form of kinship and courage to be our authentic selves. My piece "Odd Woman Out" in a show a couple of summers ago, was in high demand which delighted me. Someone said to me "It's because your work gives people permission to accept this and that about themselves."

It's my nature, and as an artist it's magnified even more, to explore things deeply and thoroughly. My artwork has seen me through deep depressions and painful traumas and into moments of pure bliss, teaching me to ride the waves and wait out the darkness, and that everything is cyclical.

Van Gogh has always been my favorite painter. His passion was all-encompassing. He made art because he truly had to. If I had not begun to dedicate my life to making art, I would be dead as well. Art truly saved my life.

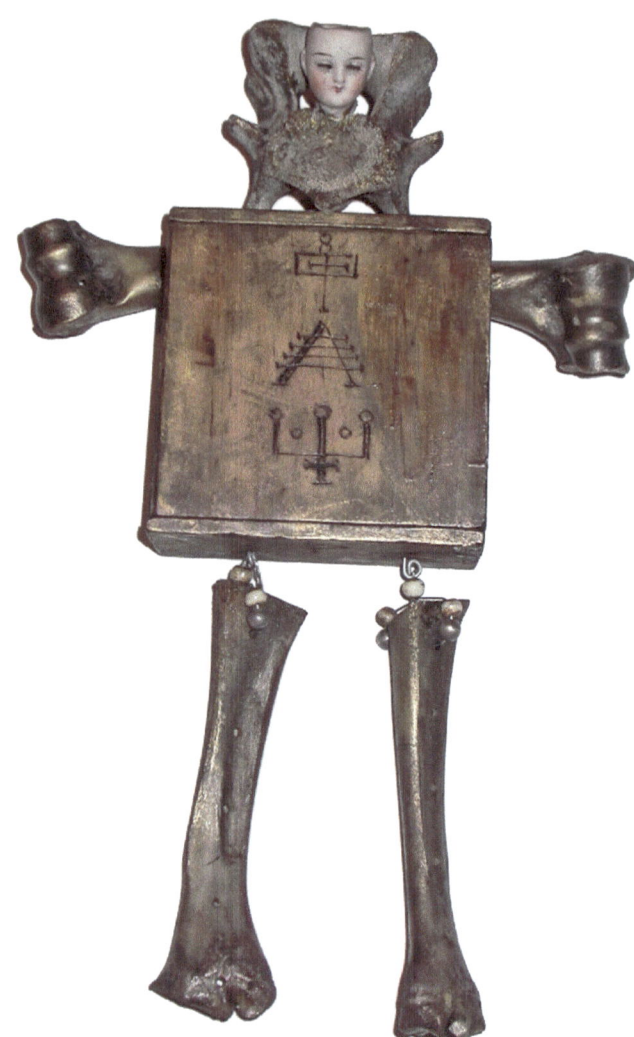

Lynn's first Bone Girl Music Box, was started after Sophia, the daughter of a friend, died in a car accident. The piece was completed after Lynn's niece Allison also died in a car accident 15 months later.

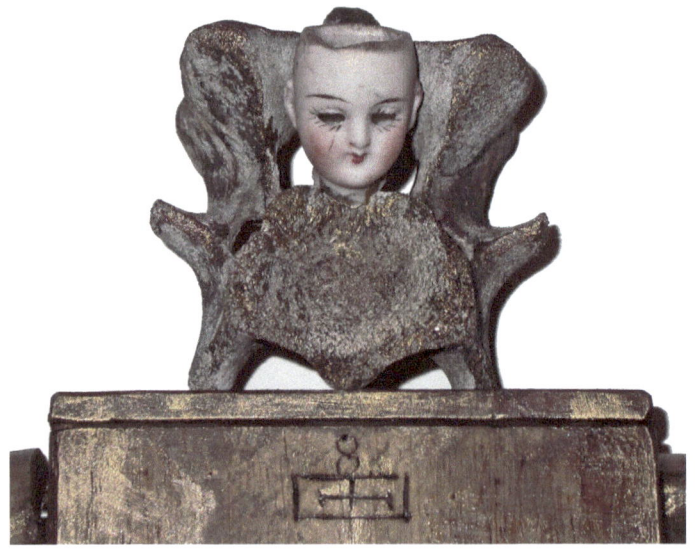

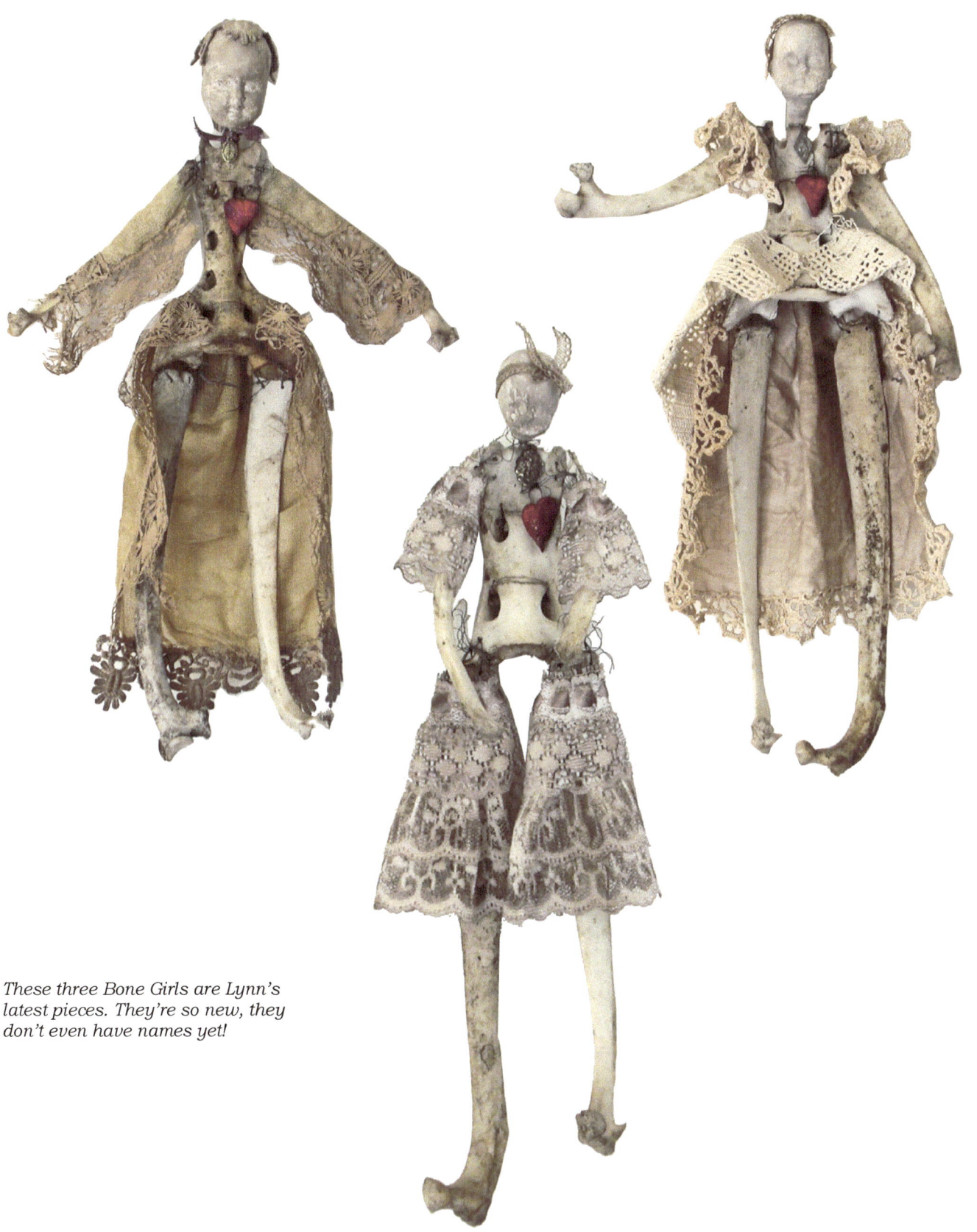

These three Bone Girls are Lynn's latest pieces. They're so new, they don't even have names yet!

Simple, Silly Stick Figures

According to Wikipedia, which devotes a lengthy page to the subject, the stick figure is a very simplistic type of drawing, generally of the human form. The head is represented by a circle, while the neck, arms, legs and torso are single straight lines. A stick figure is usually drawn by hand with a pen or pencil, giving it hard, defined edges. Simple, eh?

If you type the words "stick figure" in any search engine, you'll learn all sorts of things. There are hundreds of sites dedicated to them in various forms. For example, Stick Page, which offers movies and games based on stick figure animations. Stick figures are often used in animation, since they're so simple to draw. They're a popular subject of many short animations built in Flash, spawning stick figure characters such as Xiao Xiao and Joe Zombie. There's even an animation program, Stickfigure Animator, for people interested in created these films.

Stick figure animations have spawned a bizarre subculture on the Internet. At Stick Death, there are dozens of sites dedicated to animations, comics and drawings of stick figure fighting and stick figure death, each one sillier than the next. If you do a search on YouTube for stick figures, you'll find an endless list of short films depicting the tragic and somewhat graphic deaths of stick figures.

The same search on Flickr resulted in over 30 different groups dedicated to stick figure drawings. Some of these groups expand the definition of a stick figure to include the somewhat neutral figures used on warning signs. The group Stick Figures in Peril has thousands of photos of stick figure warning signs from all over the world. I dare you not to laugh while you're flipping through them.

Aside from being cult movie heroes, stick figures are used in serious film making. They're often used for layouts and storyboards to plan the scenes of films. They're also used in special effects work and stunt planning, to communicate placement and action of each character.

Surfing for Stick Figures

Looking for a little stick figure silliness?

On Flickr, check out these groups:

- **Stick Figures in Peril**
- **Stick Figures Who Have the Situation Under Control**
- **Altered Signs**

If you're looking for stick figure animations, do a search for these sites:

- **Stick Page**
- **Stick Death**
- **Stick Figure Death Theatre**

Several companies manufacture stick figure products for paper crafting. Check out these designs:

- **Me And My Big Ideas**
- **Paperkins**

My favorite silly stick figure comic is Cyanide and Happiness. You can find these comic strips at Explosm.net.

Art By Jen Worden

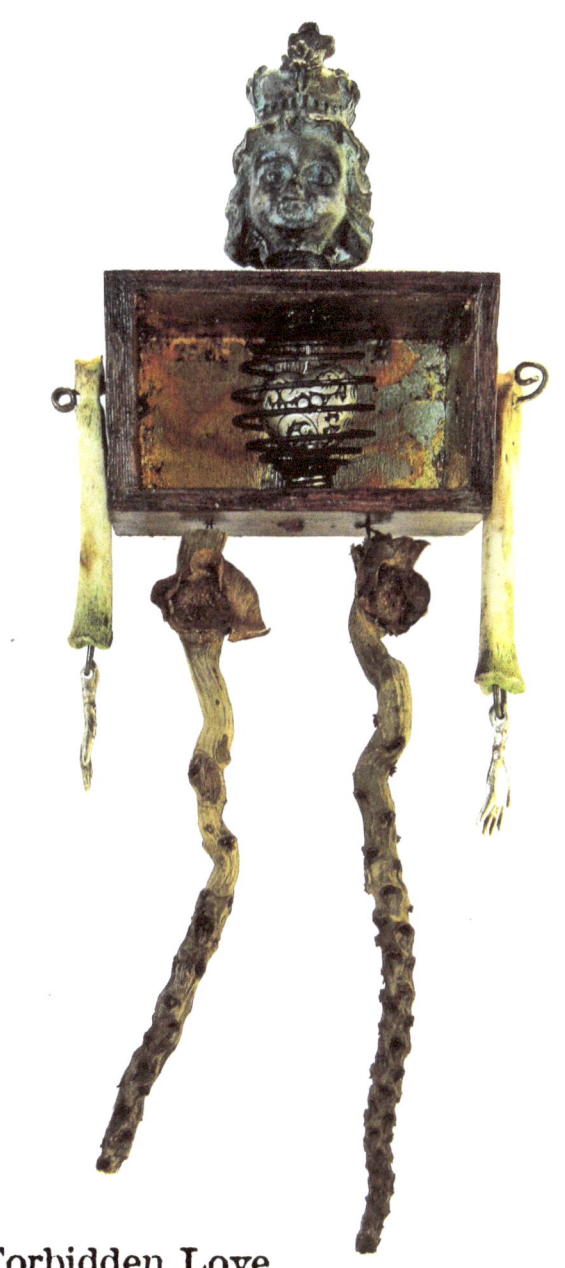

Forbidden Love
Assemblage

wooden box, plastic head, wire cage, metal heart, bones, sticks, hand charms, acrylic paint, gold leaf

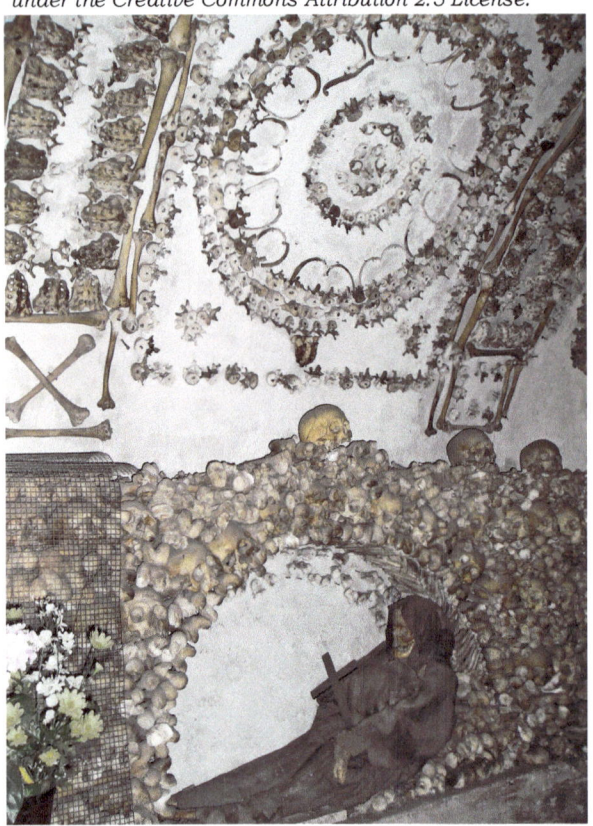

Photo courtesy of Wikimedia Commons, under the Creative Commons Attribution 2.5 License.

Discovering Ossuaries

ossuary

noun -
A chest, building, well, or site made to serve as the final resting place of human skeletal remains.

I spend a lot of time pouring over photos on Flickr, looking for other people who like to photograph cemeteries. Last year, some photos were added to one of the cemetery photo pools that made me sit up and take notice---photos of an ossuary, showing piles of skulls and bones arranged as architectural elements.

I'd never heard the word ossuary before, and outside of horror films and documentaries on the Holocaust, I'd never seen human remains displayed in this manner. At first, I thought this might be just an isolated instance---some weird sort of tourist attraction. After a little research, I

Above: This photo of the Capuchin Crypt in Santa Maria della Concezione dei Cappuccini in Rome shows architectural and decorative elements made of human bones. The crypt displays the bones of over 4000 Capuchin friars, collected between 1528 and 1870.

Right: Think those are stone walls? Look closer! The walls of the Capela dos Ossos, or in English Bone Chapel in Evora, Portugal, are made of human bones. Built in the 16th century by a Franciscan monk, the entrance bears this warning: "We bones that are here await your bones".

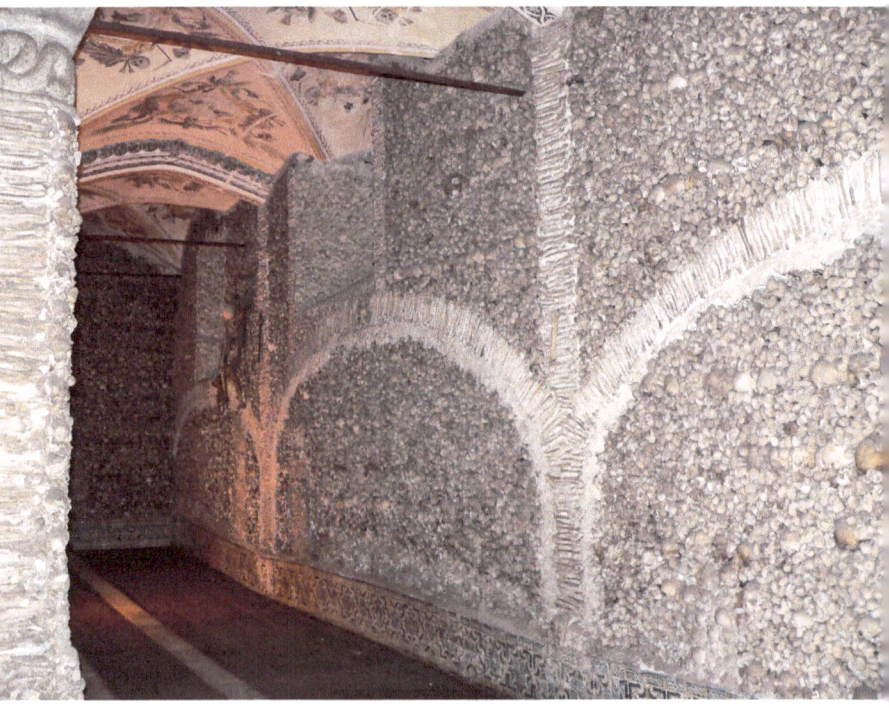

Photo courtesy of Nuno Sequeira André and Wikimedia Commons, under the Creative Commons Attribution 2.5 License.

discovered that ossuaries exist all over the world, dating back thousands of years.

Many ossuaries, such as the Santa Maria della Concezione dei Cappuccini in Rome, built in the 16th century, are built as parts of churches or cathedrals. I'd seen the bones of saints displayed in the altar area of several churches while travelling in Europe, and the tombs of famous people in the floors of Italian cathedrals. The photos of these churches go far beyond that, showing thousands of skulls and bones.

The original photos I saw on Flickr were of Sedlec in the Czech Republic. The ossuary contains roughly 40,000 human skeletons, many of which were exhumed in the 1400s during construction of the Gothic Church of All Saints. The bones were initially stacked, but in the 1800s, a woodcarver was charged to put the piles of bones into some sort of order. The rather creepy results: a chandelier, garlands, and a coat of arms, all made of human bones.

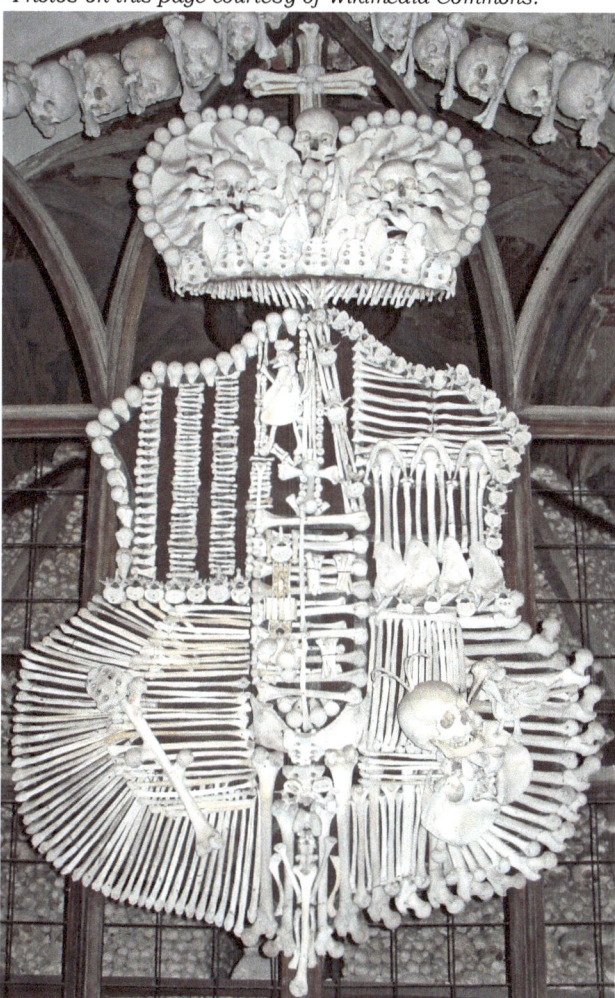

Photos on this page courtesy of Wikimedia Commons.

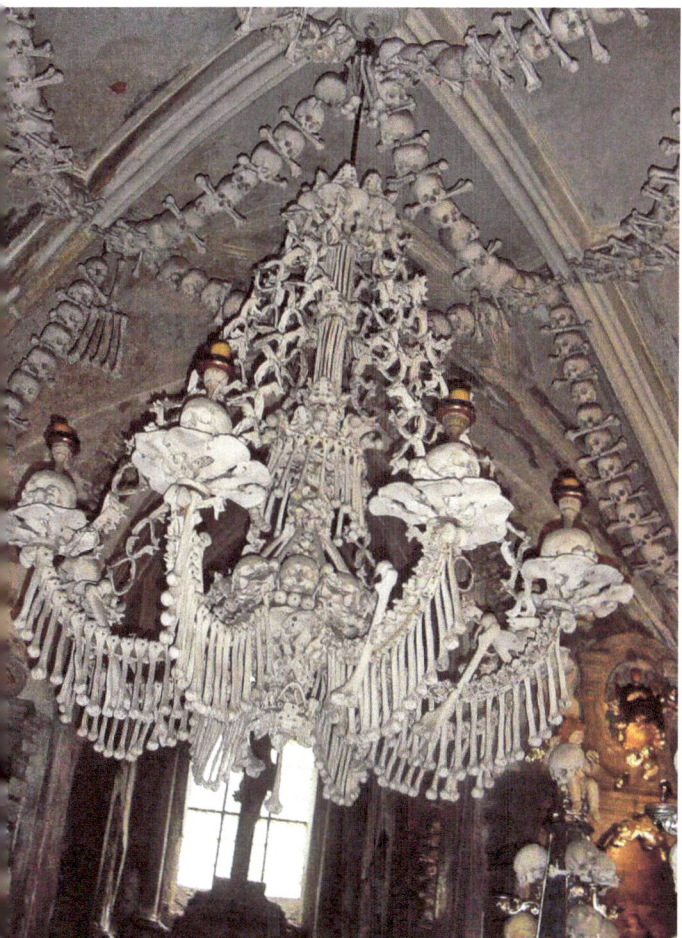

The Douaumont Ossuary, built in France at the end of World War I, holds the bones of 130,000 French and German soldiers killed during the 300 days of the Battle of Verdun. In front of the monument is a cemetery that holds 15,000 graves. The site was dedicated as a monument in 1932.

Above: This coat of arms from the Schwarzenberg, made entirely of human bones, is one of the many strange architectural details in the Sedlec ossuary.

Left: Another photo from Sedlec, showing a chandelier and garlands made of human bones.

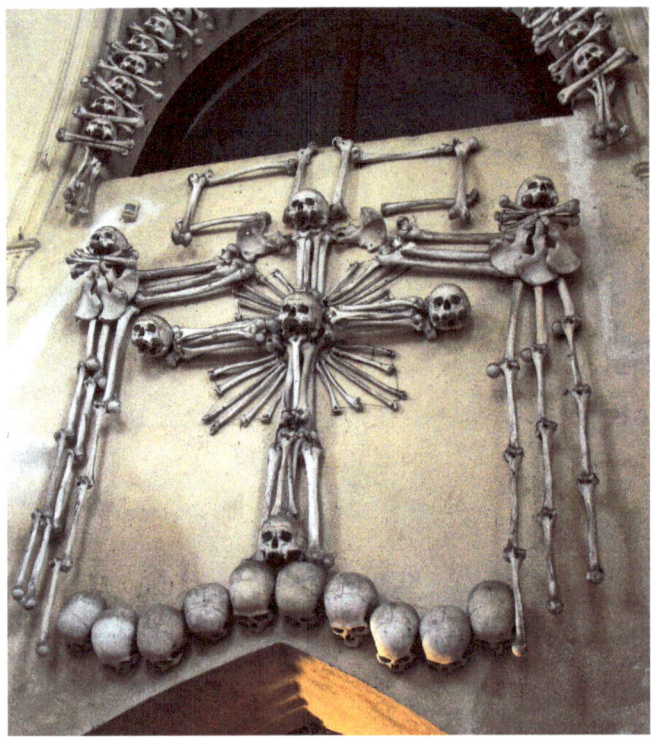

Left: The decoration above this archway in the Sedlec ossuary shows human skulls and bones arranged into a cross.

Bottom Left: Another view of the chandeliers and garlands in Sedlec, along with four tree-shaped Baroque monoliths made of skulls and bones, and topped with cherubs playing musical instruments.

Bottom Right: Every artist should sign their work! The signature of František Rint, the woodcarver who created many of the stranger ornaments in Sedlec, is made of bones embedded into one of the walls of the chapel.

Photos on this page courtesy of Wikimedia Commons.

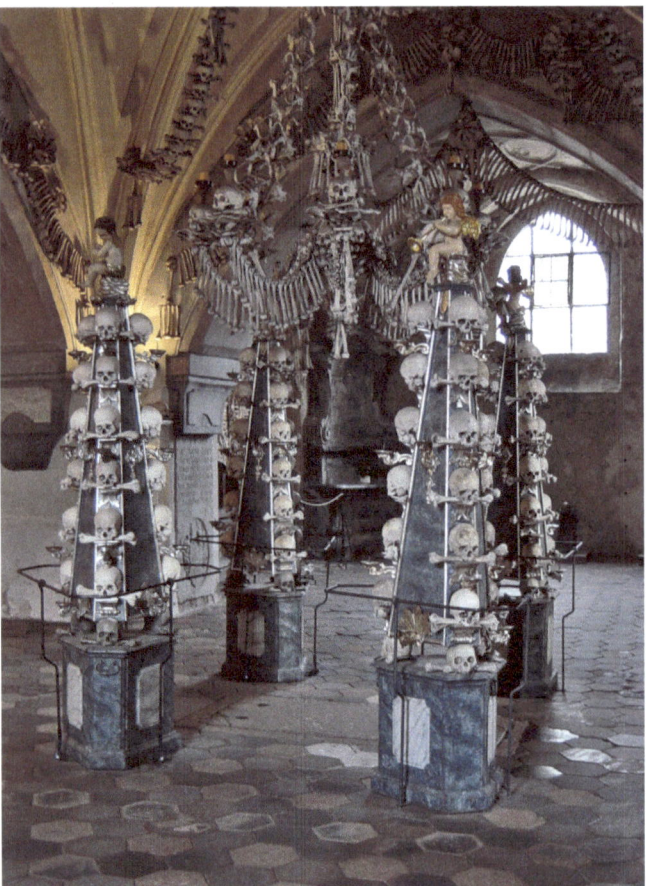

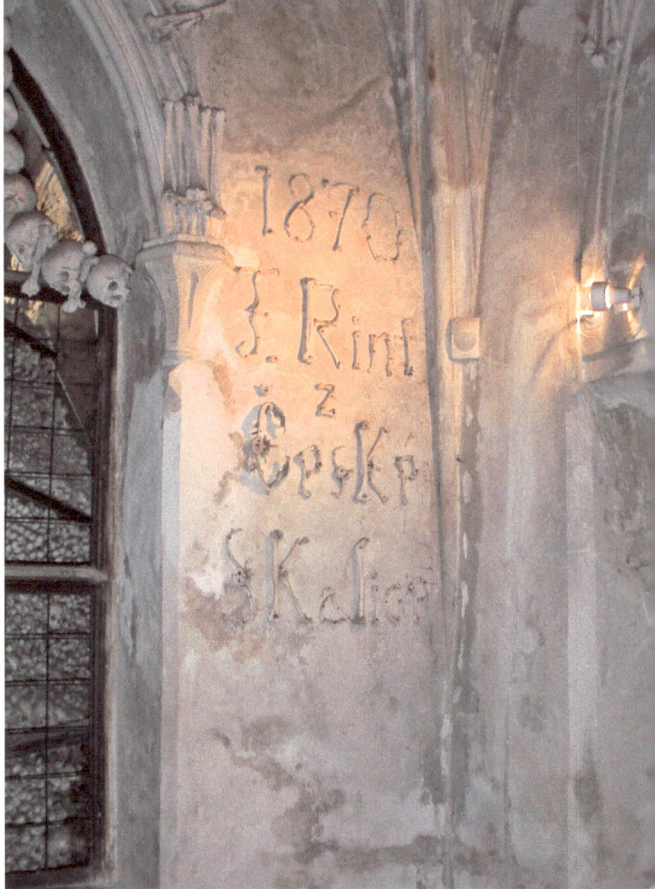

Art By
Scout Granier

Fetish Necklace

"This necklace started as a bag of talismans, charms, fetishes, and beads that I had collected together at least four years ago. I kept searching for the perfect project to use them on. When I saw an article on little waxed linen baskets in a beading magazine, I knew I had found my project. The necklace incorporates semi precious stones, bone carvings, wood, handmade glass beads, and at least four hours of trying to get the necklace part just right!"

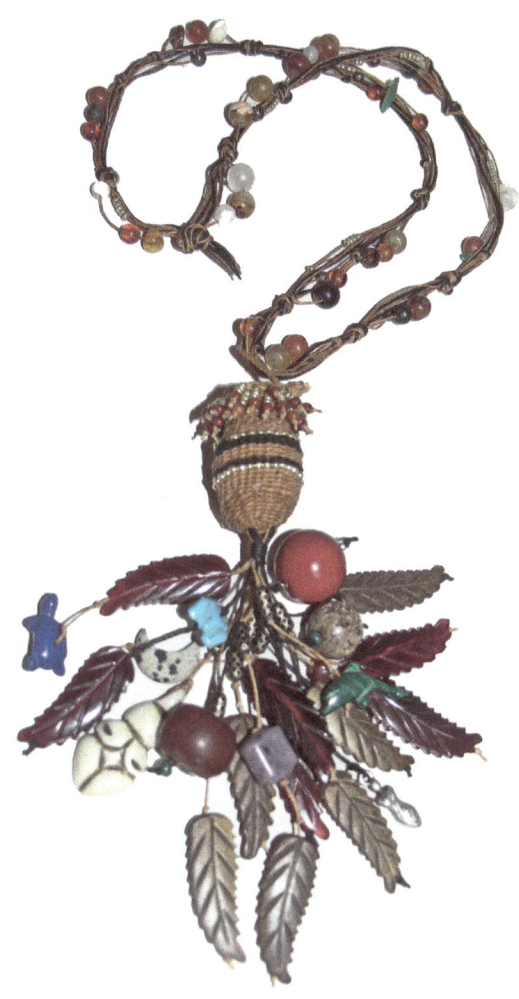

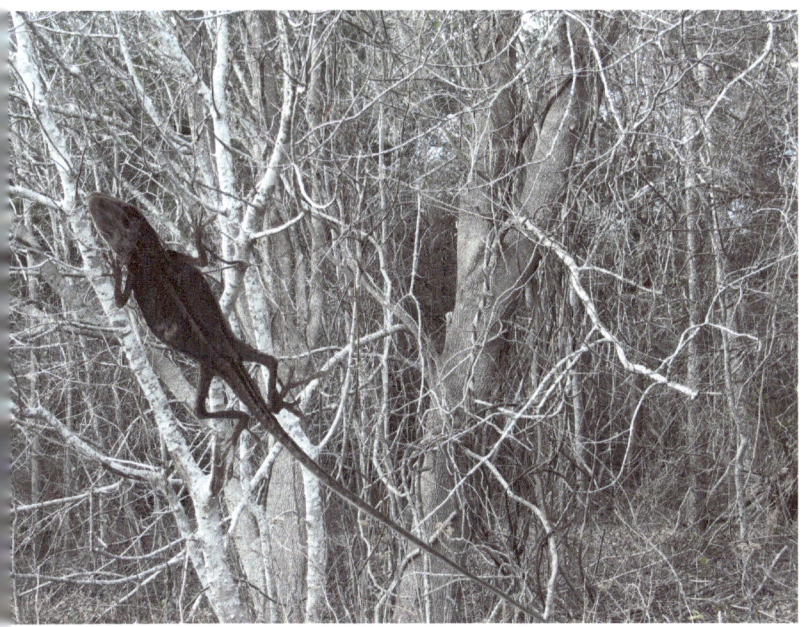

Art By
Diane Ferguson

White Trees With Lizard
Digital Collage

"Does this skin make my tail look too long? Should I slip out of it?"

Just Call Them Stick Dolls

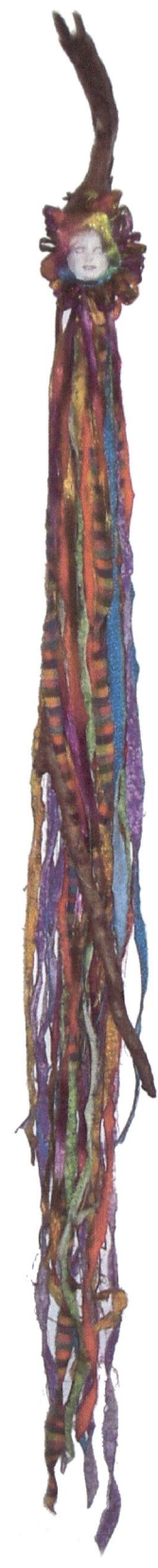

After many years of designing costumes and creating elaborate clothing for my own artist teddy bear line, you'd think that my art dolls would resemble something human, or at least have recognizable clothes.

Think again.

Three years ago, I wrote a quick article on no-sew art dolls, based on some wrapped fabric dolls I made for a swap. Today, I'm still exploring this same sort of wrapped, no-sew technique, but on a much larger scale.

My usual art doll now starts with a stick. Or possibly two sticks. The sticks might be the body, or the arms, or just the background on which to build. There may not be a body, or arms, and there are almost never any legs. My dolls aren't going to run off anywhere...

There's almost always some kind of fabric involved, either strips or squares, wrapped and knotted and tied with fibers rather than sewn---for some reason, I still can't quite make the leap back to sewing fabric. My choices in fabrics has changed quite a bit, as well. Where I used to fawn over velvets and silks, I now look for burlap and nubby cottons. When I found burlap shot with gold threads last Christmas, I thought it was the most wonderful addition to my doll making stash in quite some time.

In the majority of my mixed-media work, I'm not big on fibers, but with dolls, I can't seem to get enough. Lots of things dangling down are often a requirement. I do a lot of tying and knotting. I'm also usually not a big fan of beads or charms, but they show up quite a bit on these dolls. All those fibers can't just hang around unadorned, I guess.

Faces are usually cast in air-dry clay, and painted strange colors, or left a stark white. They're only vaguely human, or perhaps some sort of unearthly creatures.

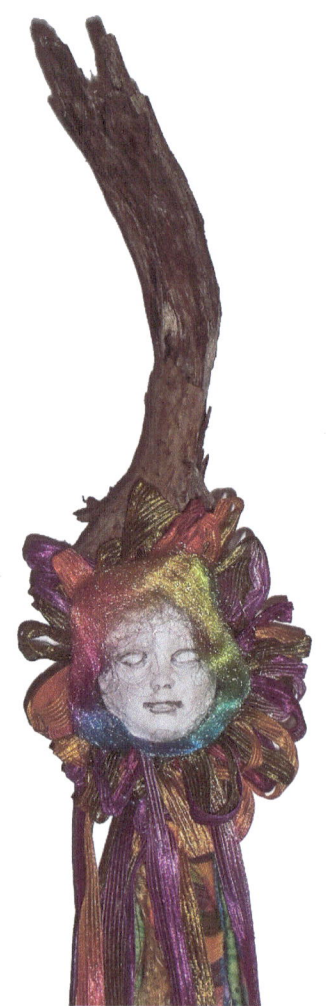

The stick doll shown on this page has been hanging around my studio for a good two years now, and I'm still not sure she's finished. Made from a part of a branch from the backyard tree that was cut down last year, she's roughly four feet tall.

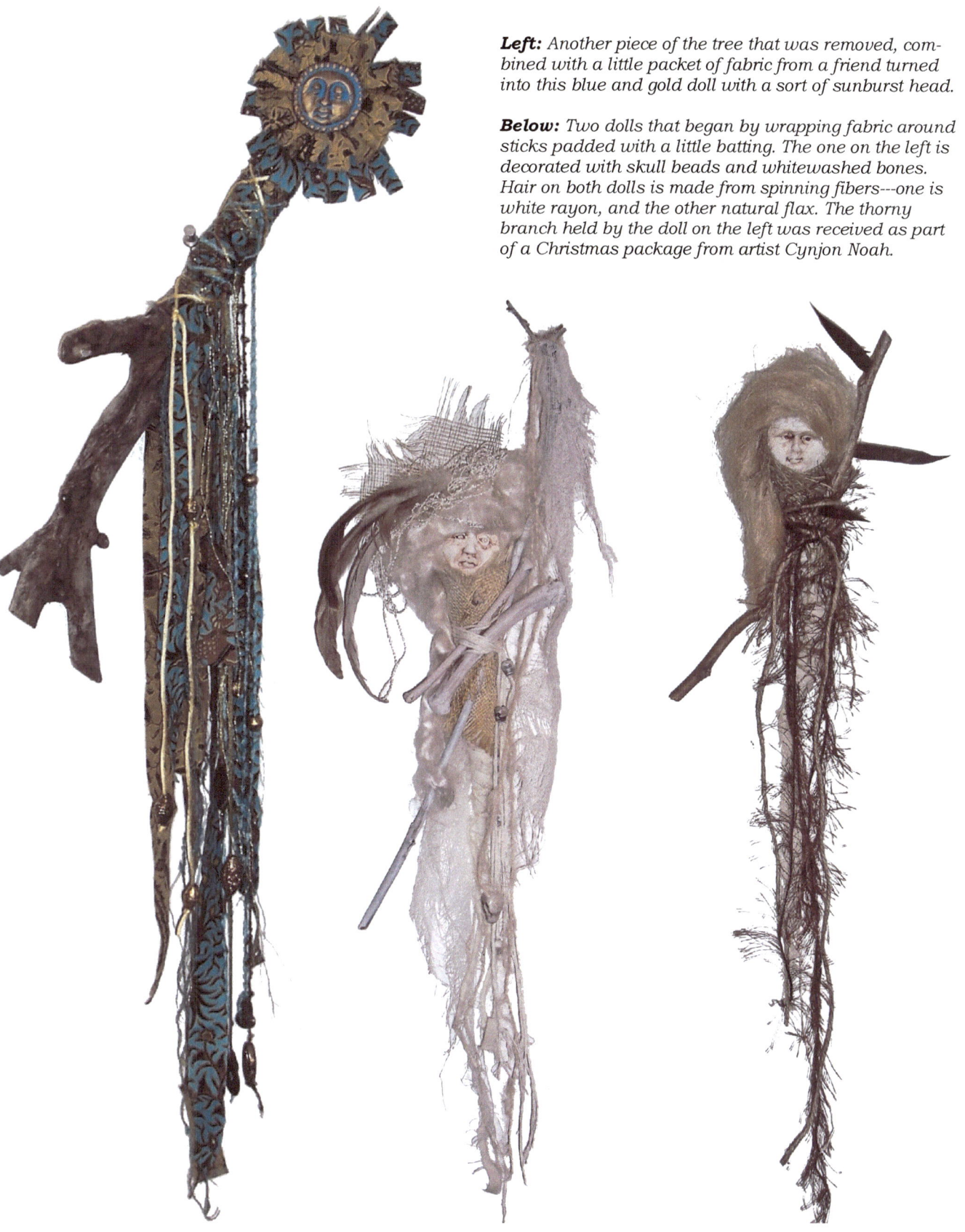

Left: Another piece of the tree that was removed, combined with a little packet of fabric from a friend turned into this blue and gold doll with a sort of sunburst head.

Below: Two dolls that began by wrapping fabric around sticks padded with a little batting. The one on the left is decorated with skull beads and whitewashed bones. Hair on both dolls is made from spinning fibers---one is white rayon, and the other natural flax. The thorny branch held by the doll on the left was received as part of a Christmas package from artist Cynjon Noah.

Coming in June
or whenever I get around to it...

Bad Influence
Issue #5 - Mysteries of the Garden

Call for Art & Submission Guidelines for Bad Influence Zine

June Theme: Mysteries of the Garden
Submissions due at Ten Two Studios by May 1st.

Please submit artwork based on the theme Mysteries from the Garden. All media is welcome, but particular interest will be paid to photography, collage and digital artwork. This issue will contain both black and white and full color images.

If your piece is used, you will be credited by whatever name or pseudonym you wish, and will receive a free copy of the zine in appreciation of your submission. Artists retain full rights to their submitted work.

Non-themed art is not being accepted at this time

Submission Guidelines
Please submit photographs or scans of work to TenTwoStudios@yahoo.com in the following format:

- Full color images.
- High resolution - 300 dpi.
- Artwork photographed or scanned against a WHITE background.
- Saved as .jpg or .tif images.
- Attach ONE image per email, and include your name, the title of the piece, and a short description.
- Please include a two sentence biography with your submissions. (See page 3 for examples.)

www.ingramcontent.com/pod-product-compliance
Lightning Source LLC
Chambersburg PA
CBHW050433180526
45159CB00006B/2524